ROBBERT FLICK

Sequential Views 1980–1986

Sequential Views : 1980 — 1986

Photography is an immediate and persuasive medium. Yet there is also a slightly peculiar distance in photographs, as if they partially occupy another plane or dimension of existence beyond perceived reality. For despite whatever insistent or assertive qualities are present, a photograph is often about something other than what it immediately appears to be.

Robbert Flick's **Sequential Views** immediately signal a viewer that something of a greater and different order than what is possible in a single image is at stake. Flick's earlier work involved an attitude which he has since termed an "empathic mode". Using this methodology photographs and ideas were guided by emotional and subjective responses over an extended period of time. For example, the pieces in his **L.A. Diary** (photographed 1969–71) consist of many images layered into single views, while individual images were codified into sequential groupings in the **Midwest Diary** (photographed 1971–76). He deliberately adopted a systematic methodology for the serially gridded **Sequential Views** (1979–present) in order to extend a perception of photography as an expressive and abstract visual language.

A **Sequential View** is a framework, a pattern of movement and a map. It requires that a viewer trustingly accept whatever exists in adjacent frames, and that any preconceived expectations be abandoned. Each work has an autonomy as something separate from what is pictorially represented. Each frame harbors something of the evolution of Flick's concerns over time —like any section of a molecular strand of DNA holds the coding for the entire chain. A **SV** is a complex layered system; it is a meta-language about the processes, effects and experiences possible through photography.

The experiential dimension of the work is activated when the parts and framework of a **SV** are explored, and the map becomes something more than a report, description, or process record of what is represented. A **Sequential View** holds both the specifity of single photographic images and the elusive patterns of a simulated construct. They are brought together in a skillfully measured cadence which envelops a viewer with the potential for new levels of experience and meaning.

The earliest **Sequential Views** are based on a preconceived conceptual process. Detail, perspective and content change frame by frame through methodical shifts in lens focal length and vantage point. Light and shadow remain relatively constant, being used later to modulate the depth or flatness of pictorial space. There is no need for the construct to be rational or based on a prescribed form of measurement for it is a **tracing of points of attention in time.** It has an artificial temporality, a simulation and construction of temporal experience, rather than a time-bound logic like a continuous strip of movie film. This dimension interweaves the referential nature, conjunctions and projections of multiple view points into a highly potent series of perceptual and philosophical operations.

It is precisely the temporality of a **Sequential View** that is of a profoundly different order than the most complex single image. While some of Flick's earliest **Sequential Views** have a discernible visual bias of horizontal or vertical orientations and time movements, a less predictable organization of the segments begins to appear in works produced near the end of the **"Los Angeles Documentary Project"** (1981). A viewer is struck by an equanimity in the synthesis or visual weighting of the frames throughout the construct. It is a simulation that is the engagement of an encompassing and projective vision.

The term "simulation" marks an important distinction between a **Sequential View** and its identifiable content of landscape. It is an alternative to lived experience, balancing an awareness of rhythms and evolving processes in a landscape with an art practiced over a period of time. Movement and vision of a place are marked by observation based on daily circumstances. The interwoven chains of biological life may be notated in various ways such as the modulating aspects of atmosphere and time of day, or the way a place may take on anthropormorphic qualities through how it is pictured.

The structural assembly of this catalogue chronologically marks Flick's stylistic maturation, while guiding a viewer to the intricacies of what is revealed in the **Sequential Views.** The works establish their own temporal dimension—one that is suspended and not fixed. This "re-creation" of time is an essential factor when viewing the work for a **Sequential View** becomes a sequence of motion and fact which combine to generate a statement.

The **Sequential Views** exist as a balance of <u>interior</u> and <u>exterior</u> landscapes. An exterior landscape will have some discernible and identifiable relationships, and others which are uncodifiable or ineffable. All may be put into some form of purpose or order, however inscrutable they appear to be. Likewise, an internal landscape may embody ideas, speculations and intuitions which are rational, describable or impenetrably subtle. A **Sequential View** is not simply the naming or identification of things in a place, but a perception and establishment of real and potential relationships. It is an organization that visually harmonizes inner and outer landscapes, and as a result is likely to be lyrical, disjunctive, occasionally confusing, startling and wonderous.

A song is comprised of musical notes which can be notated on paper. The performance of a song can be recorded and played back through various devices designed to simulate the audial experience. Yet while the melody, structure and sound of a song are real, they cannot be touched. A **Sequential View** is not the landscape depicted in the photographic frames, for the reality of a landscape as a photographic image exists between the optically mediated and process derived marks of a paper print and that image experienced in a viewer's mind's eye. Meaning is achieved through feeling and thinking about what is fabricated through the language of a medium. It is precisely this process—thinking about that discrepancy between reality and what is rendered in the multiple photographic frames—which frees the **Sequential Views** and gives them their own pulsating life.

Mark Johnstone

連続した視点：1980—1986

写真は直接的で説得力のあるメディアである。しかし写真にはその特有な距離感も存在する。まるで、知覚できる現実を越えた存在の持つ別の面や、異次元を部分的に含んでいるかのようである。どんなに執拗な独断的な面が存在していても、一枚の写真の持つ意味は、第一印象とは別ものことが多いのである。

ロバート・フリックのSequential Views（連続した視点）を見た場合、直ちに感じるのは、何か一点だけのイメージで表わせるもの以上の、異なった秩序である。フリックの初期の作品には「強調された様式」と彼が呼ぶ姿勢が見られる。この方法をとることによって、彼は長期に亘って感情や主観に頼って写真やアイディアを生み出した。例えば、L.A.Diary（1969—71年撮影）と題する作品は、複数のイメージをあるひとつの情景にまとめあげている。Midwest Diary（1971年—76年撮影）では個々のイメージを連続したグループに編集している。彼は、連続した格子状になっているSequential Views（連続した視点、1979年—現在）に向かって意図的に系統立った方法論を採ってきた。そうすることによって写真に対する認識を広げ、写真を表現力豊かな、抽象的な視覚言語として確立したかったのである。

Sequential Viewは枠組みであり、動きのパターンであり、地図である。これを見る者には、隣り同士に何が来ているかをそのまま受け入れ、一切の先入観を捨てて欲しいということだ。それぞれの作品は、絵が表現するものとは何か別の自律性を持つ。フレームごとに、フリックが長年培ってきた関心の発展をみることができる。それはあたかもDNAのどの分子螺旋にも、全て連鎖の情報が記憶されているのと似ている。彼の連続した風景は複雑に層をなす様式であり、写真を通してどんな制作過程や効果、実験ができるのかを表わす高等論理言語である。

作品の実験的な次元は連続風景が探究され、地図が単なる報告や表現過程の記録にとどまらず、それ以上のものになったときに、より活性化する。Sequential Viewには一点の写真イメージの持つ特定の情報と、虚構によるつかみにくいパターンとが共存している。それは器用に計算されたリズムのなかに包まれ、新しいレベルの経験や意味を問いかけてくれる。

最初のSequential Viewsの作品は、あらかじめ持っていた概念的な過程に基づいている。フレームごとに細部、遠近感と対象物がレンズの焦点距離と位置を変えることで変化する。光と影は比較的一定にしておいて、後に写真空間の深みや平坦さを調節する。できあがりの構成が論理的であったり、処方せんに従った測量法に基づいている必要はない。というのも、これは「同一時間内に、注意をひいた様々な場所を描く」ものだからだ。そこには人工的な一時性があり、つかの間の経験を似せて再構成している。これは、映画フィルムのつなぎ合わせによる連続時空理論とは異なる。この次元は、複数の視点による関連のある性質、連結そして投影を織りなし、知覚的並びに哲学的な行為という点で、高度に可能性のあるシリーズに昇められている。

これは正にSequential Viewの一時性が、他の最も複雑な一点の写真に比べて著しく異なる点である。フリックの初期のSequential Viewsの中には、傾向として縦や横の流れ、時間の動きが顕著に出ているが、彼の

Los Angeles Documentary Project （ロサンゼルス・ドキュメンタリー・プロジェクト、1981年）の作品の後半ではまだそうした部分は予測しにくい。彼の作品には全体を通して統合体の中の平静さ、フレームが与える視覚効果の重みがあり、視る者を打つ。それは、包括しつつ投映する、視点のシミュレーションなのである。

「シミュレーション」という用語は、Sequential Viewと、実際使われている風景との間の重要な区別を表わす。それは生きた経験を代替することであり、じっくり時間をかけて熟成させた芸術をもってリズムに対する意識と、風景が変遷してゆく過程を表現している。日常の状況を観察することで、彼はある場所の持つ動きと視点を表明している。絡み合う鎖のような生物学的な人生を表現する方法はいろいろあるだろう。一日の大気や時間が変化してゆく面をとらえたり、あるいはどう写真に撮られるかによって、ある場所は人間らしさを持つこともある。

このカタログでは、フリックのスタイルがどう発展してきたかを年代順に構成・編集している。これを追うことによって読者はSequential Viewsの複雑さ、何が顕著になっているのかを解くように導かれる。彼の作品には、独特な時間の次元が確立されている——それは、固定されていない、宙ぶらりんの状態である。作品を見るときの鍵になる重要な要素は、時間が「再構成」されていることだ。Sequential Viewは、動きと事実がつながり、両者が結び付いて主張を生み出すのである。Sequential Viewsは、風景の内側と外側とのバランスの上に存在する。外側の風景の中には、識別したり認識可能な関係にあるものもあれば、他方では体系化したり言葉にできないようなものもある。一見どんなに謎めいて見えようと、全て目的や秩序の下にまとめることは可能であろう。同様に、内なる風景は理性的であり、描写力に富み、かすかに微妙なアイディア、思惑、直感といったものを含む。Sequential Viewsは、ある場所に存在する物に単に名を冠したり、見分けたりすることではなく、真の潜在的な関係を認識して確立するものである。構成されたものは内なる風景と外側の風景を視覚的に融合させている。結果として詩的で、分離性があり、ときには困惑や驚き、不思議に満ちたりする。

歌は譜面に描かれた音譜によってできあがっている。歌の演奏は、レコード化し生演奏を再現するべくあみ出された様々な装置によって、何度も聴くことができる。しかし、歌のメロディーや構成、音は本物であっても手で触れることはできない。Sequential Viewは写真フレームの中に表現された風景ではない。写真イメージとしての風景の実態は、光学が介在し、プリントの上に残されるプロセスの跡と、風景を見る者の精神的な眼でとらえたイメージの経験との間に存在するのである。写真というメディアの持つ言語を通して何が作られたのかを感じ、考えることで意味を獲得することができよう。まさにこのプロセス——現実と、複数の写真フレームの中に収まったものとの相違点について考えること——によってSequential Viewsは解放され、独自の脈打つ生命を与えられるのである。

<div style="text-align: right">マーク・ジョンストン</div>

SV 11A/72-80 - Corn-1 16x20"

SV 11A/72-80 - Corn-1 detail, contact print

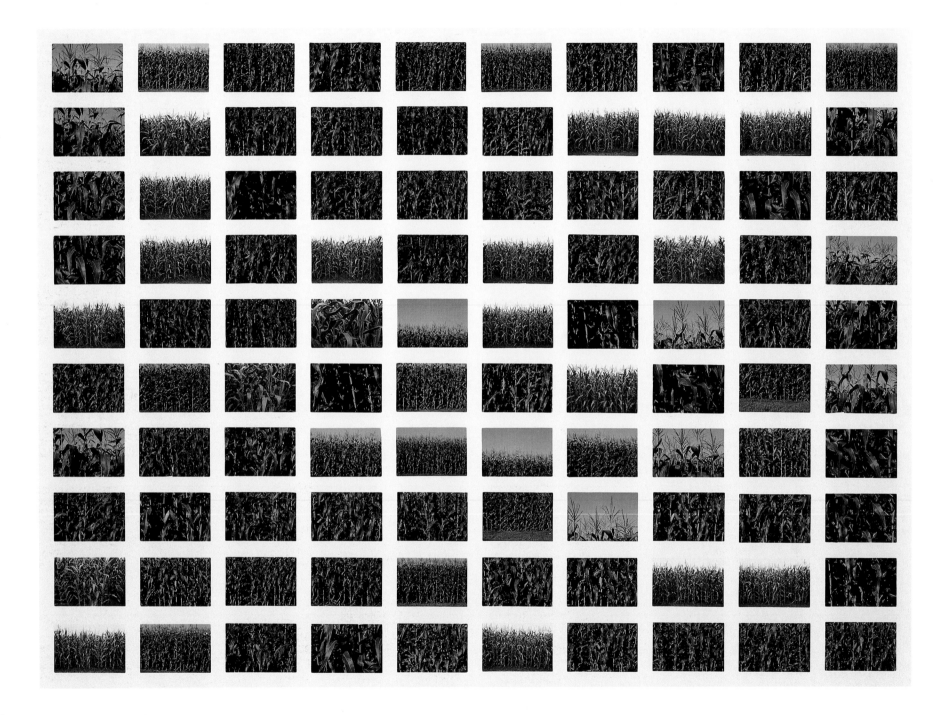

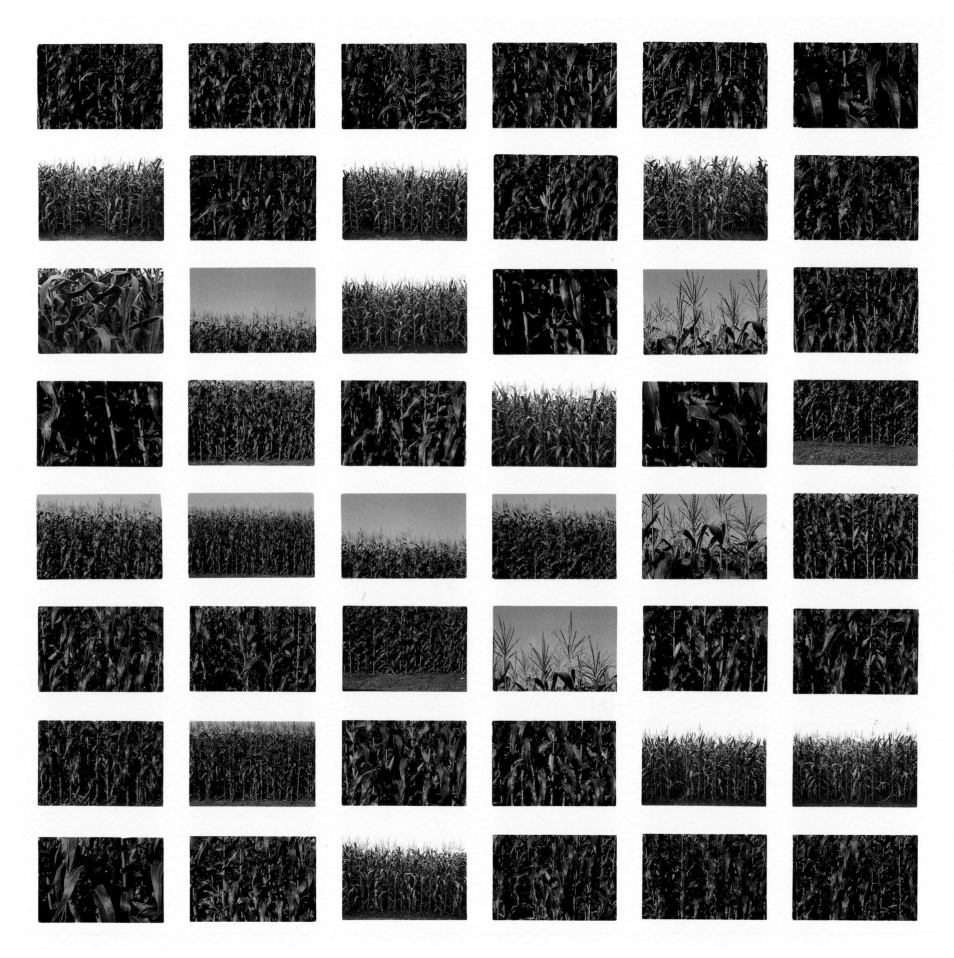

SV 11A/72—80(Detail)

LA DOCUMENTARY PROJECT

SV 8A/80 - **Manhattan Beach Looking North from Marine 20x24"**

SV 8A/80 - **Manhattan Beach Looking North from Marine detail, contact print**

SV 14A/80 - **Manhattan Beach Looking West from Vista detail, contact print**

SV 14A/80 - **Manhattan Beach Looking West from Vista 20x24"**

SV 9A/80 - **Venice Beach, 180 degree view detail, contact print**

SV 9A/80 - **Venice Beach, 180 degree view 20x24"**

SV 13A/80 - **Centinella Park Looking North along Florence 20x24"**

SV 13A/80 - **Centinella Park Looking North along Florence detail, contact print**

SV 19A/80 - **Venice Beach Labor Day Week-end 20x24"**

SV 19A/80 - **Venice Beach Labor Day Week-end detail, contact print**

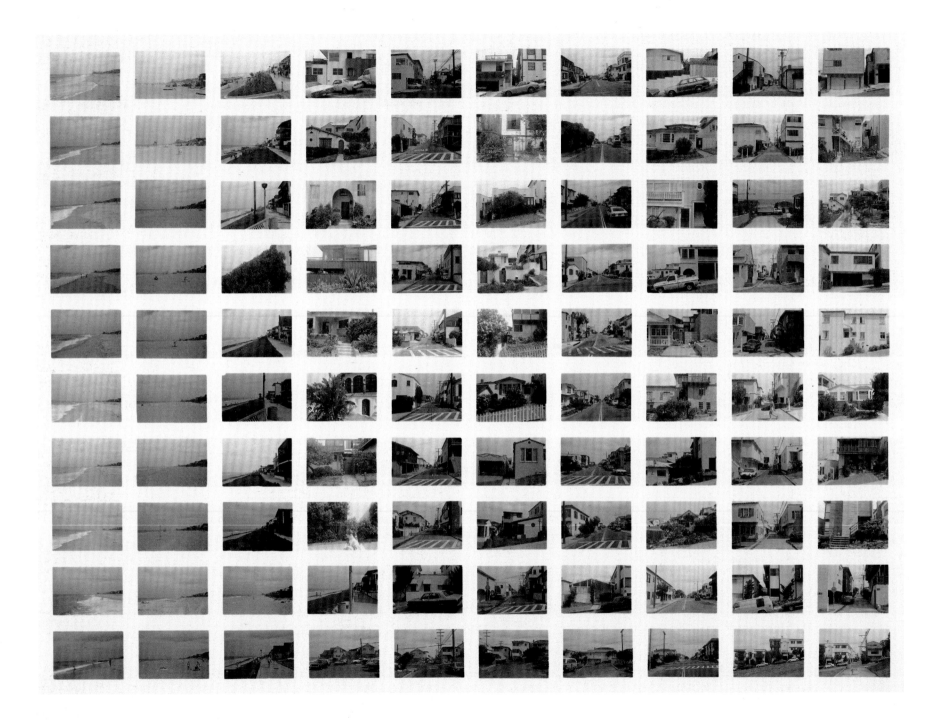

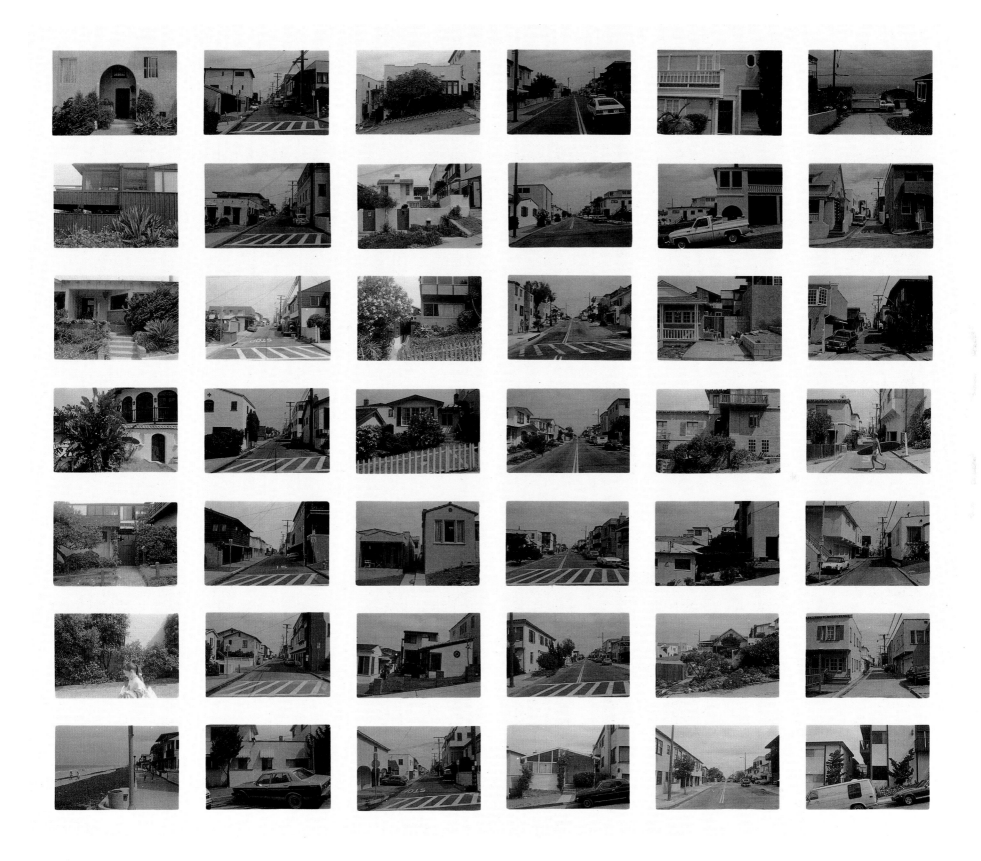

SV 8A/80(Detail)

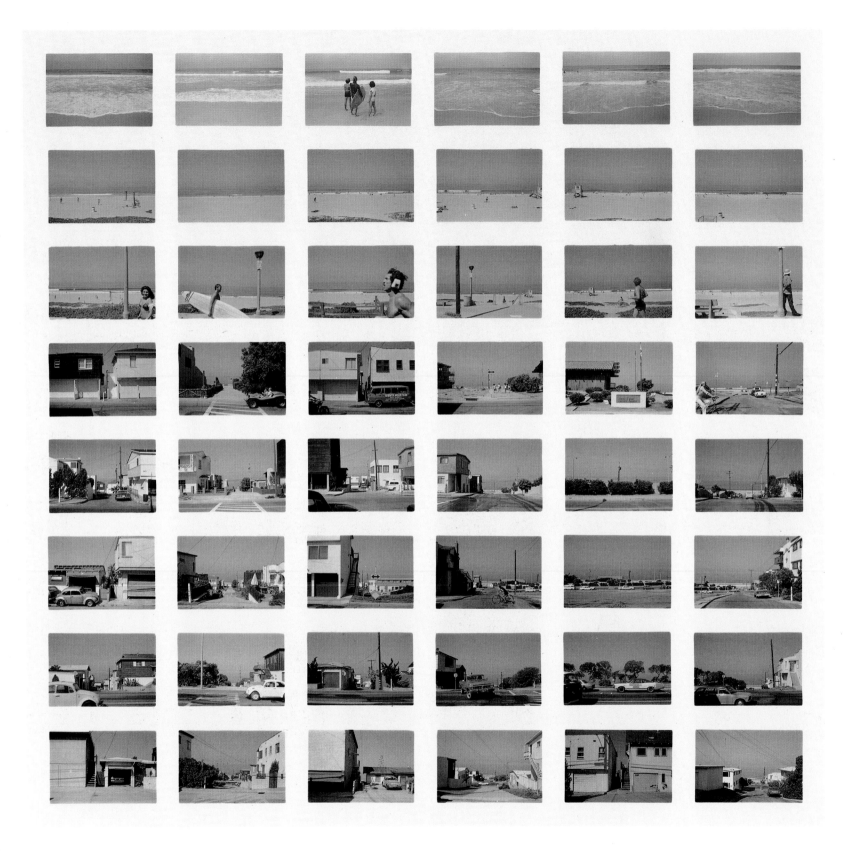

SV 14A/80(Detail)

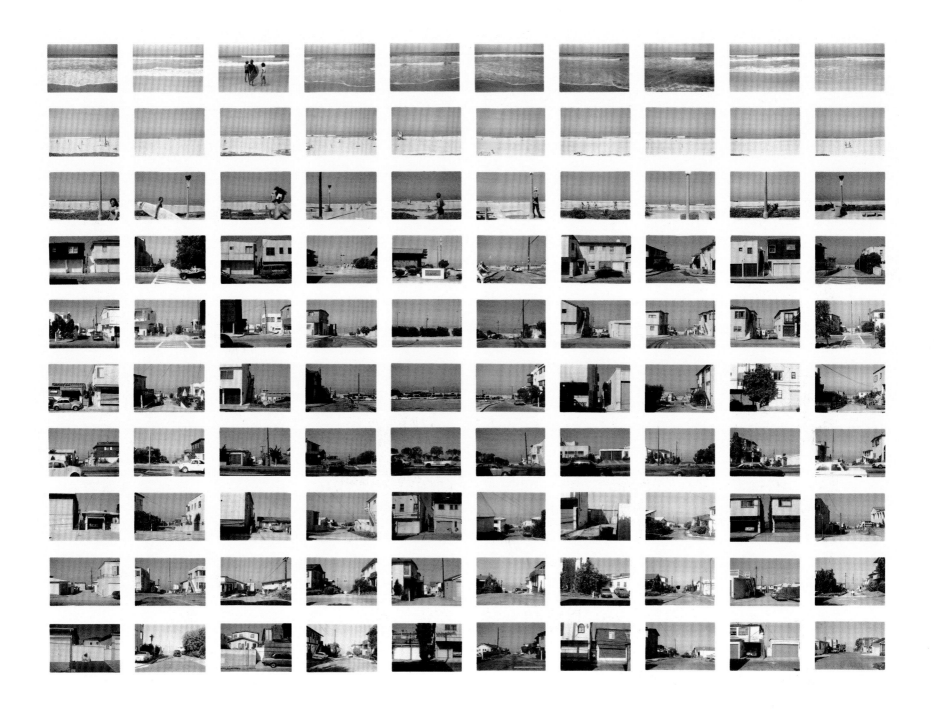

SV 14A/80

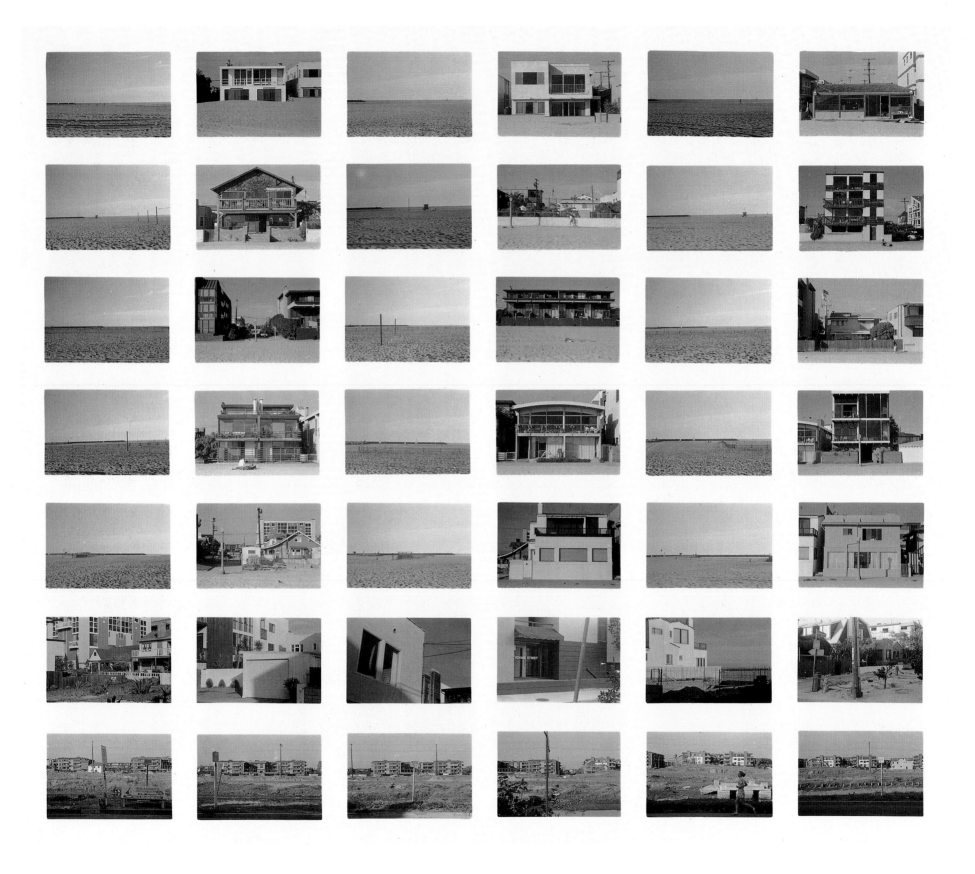

SV 9A/80(Detail)

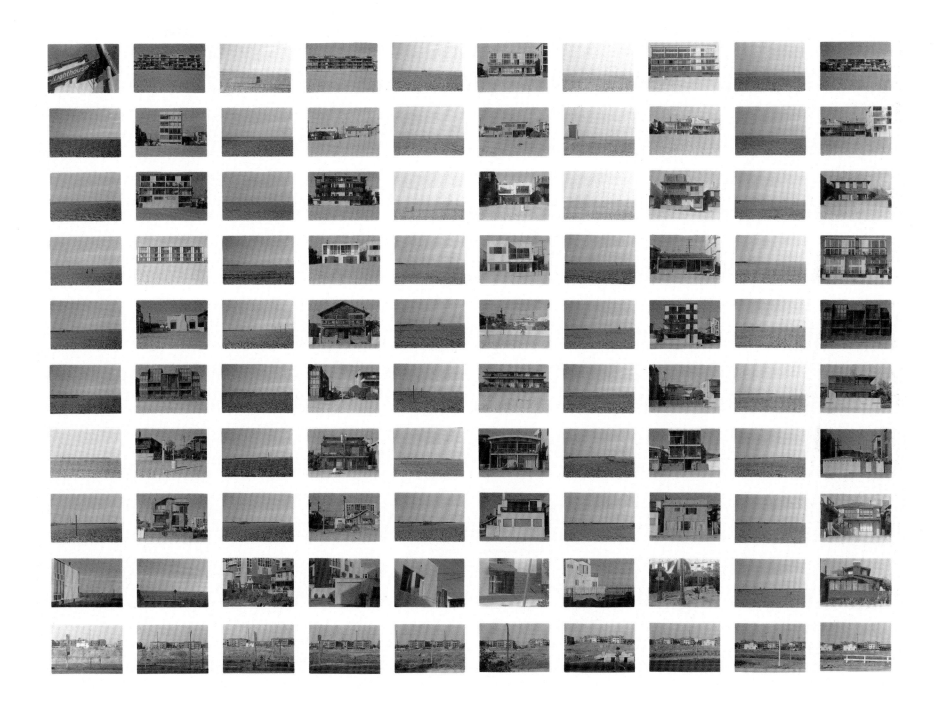

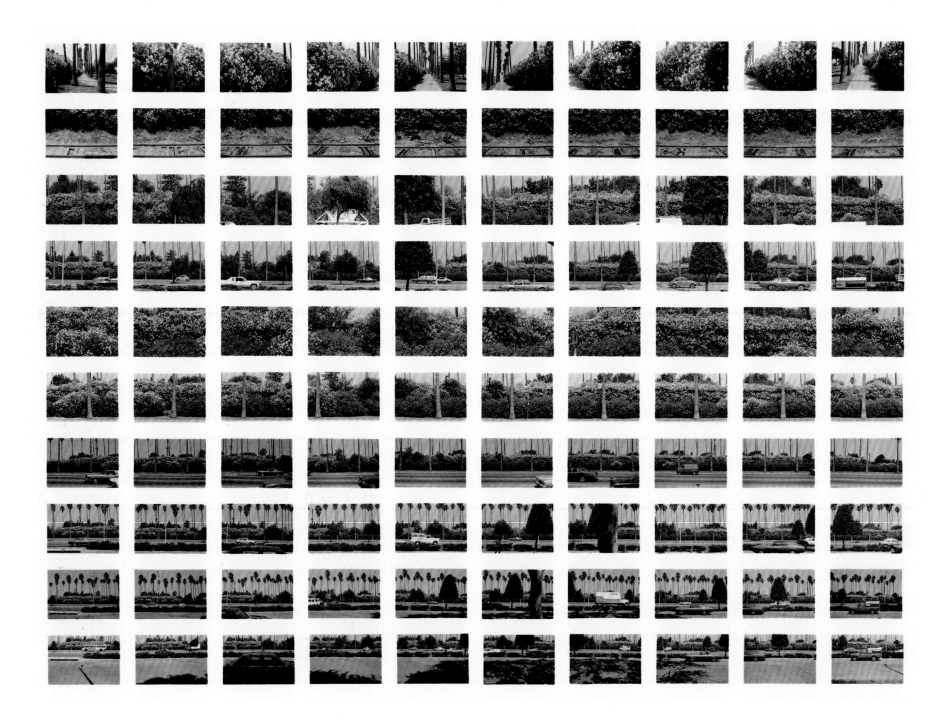

SV 13A/80

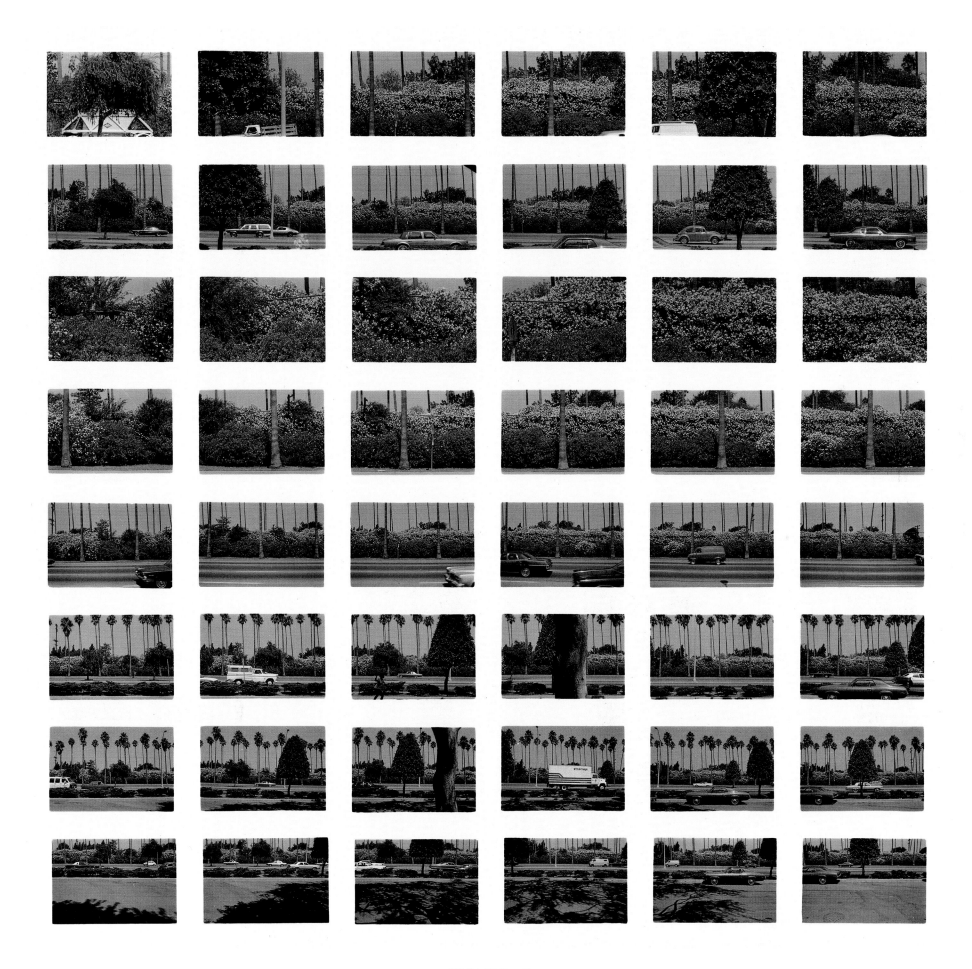

SV 13A/80(Detail)

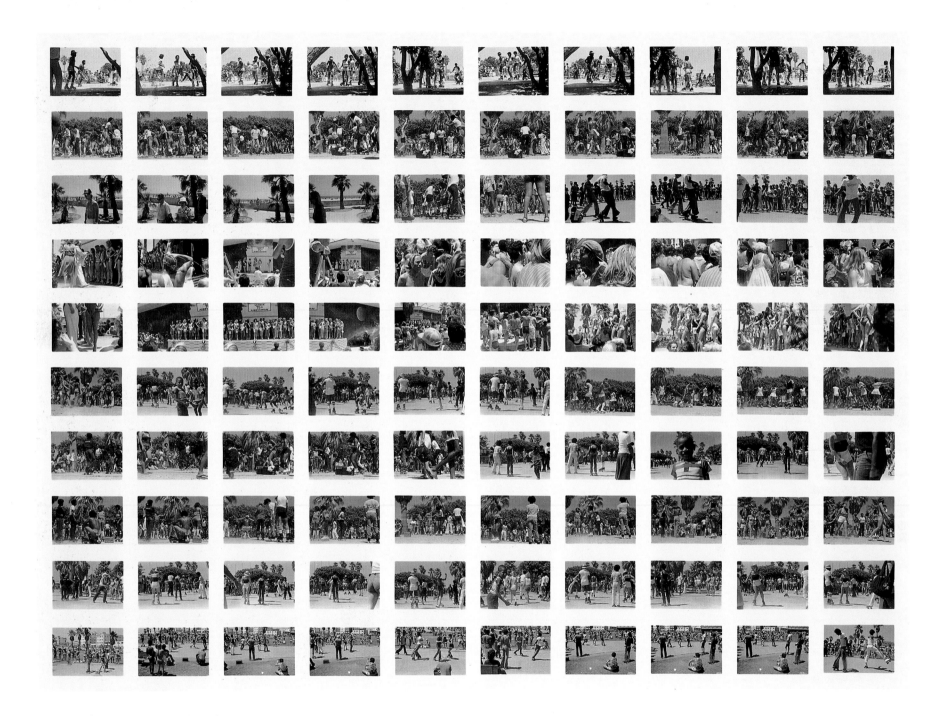

SV 19A/80

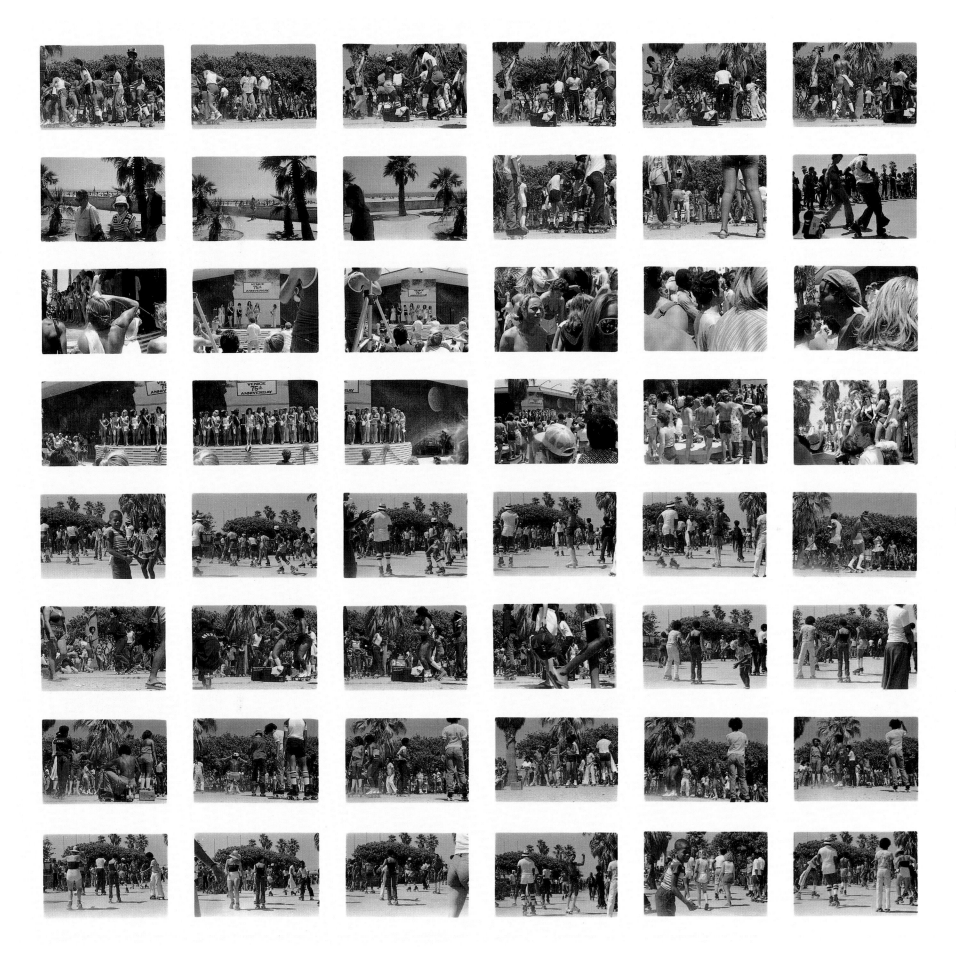

SV 19A/80(Detail)

SEQUENTIAL VIEWS

SV 22A/80 - N. of Kankakee,Illinois 20x24"

SV 23A/80 - Chicago Forest Preserve, Illinois 20x24"

SV 55A/82 - Saguaro National Monument, Tucson, AZ 20x24"

SV 37A/81 - NE of Backus Road, Kern County, CA 20x24"

SV 51A/82 - Harbor Islands, Long Beach, CA 20x24"

SV 34A/81 - Parking Structure #2, Inglewood, CA 20x24"

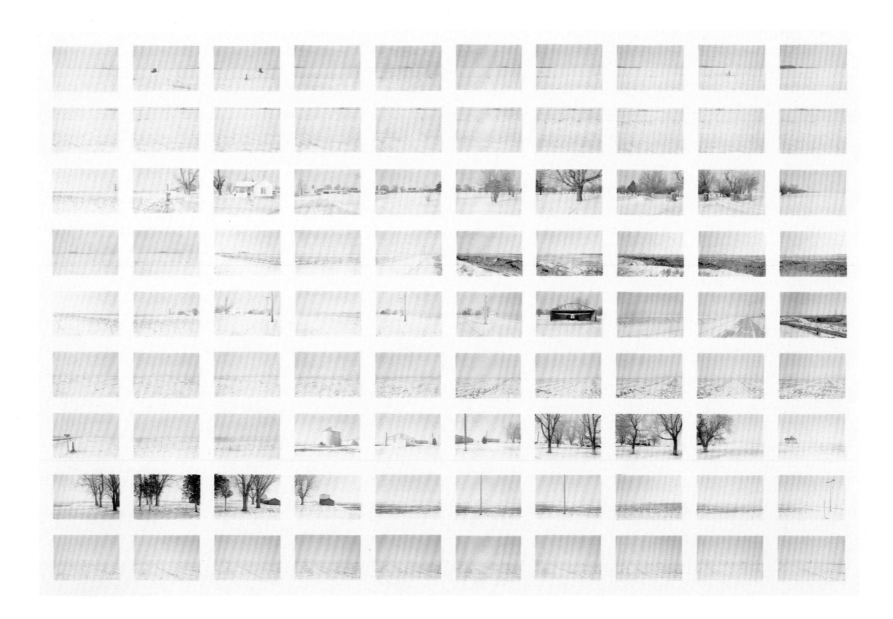

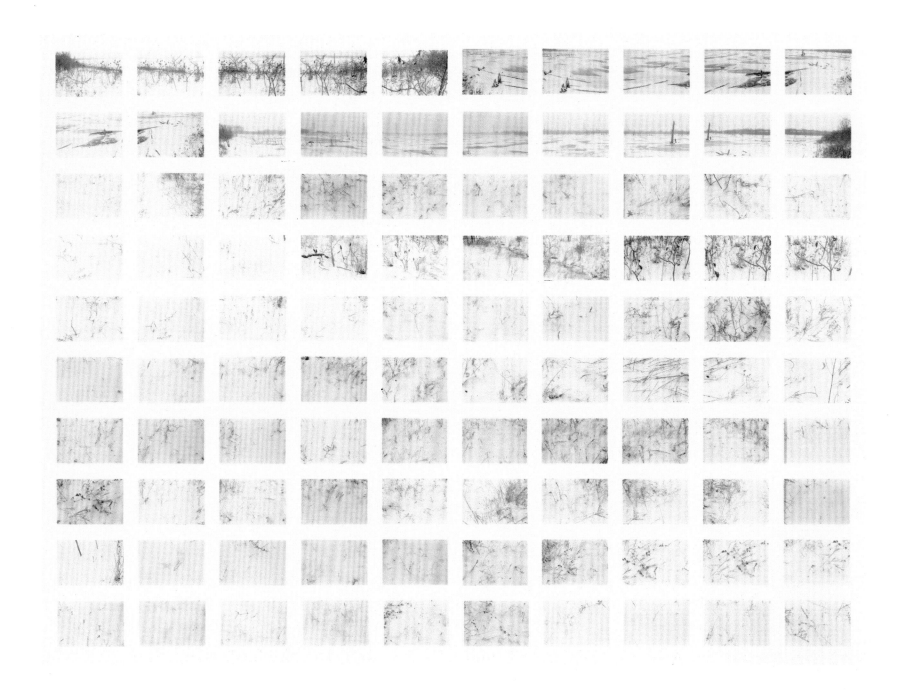

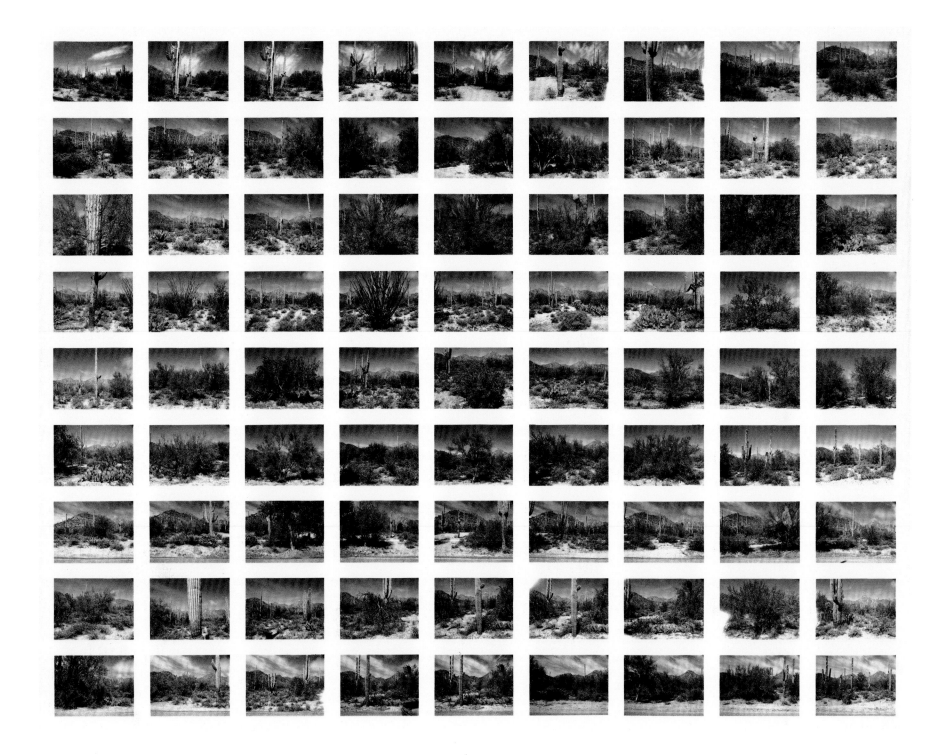

SV 55A/82

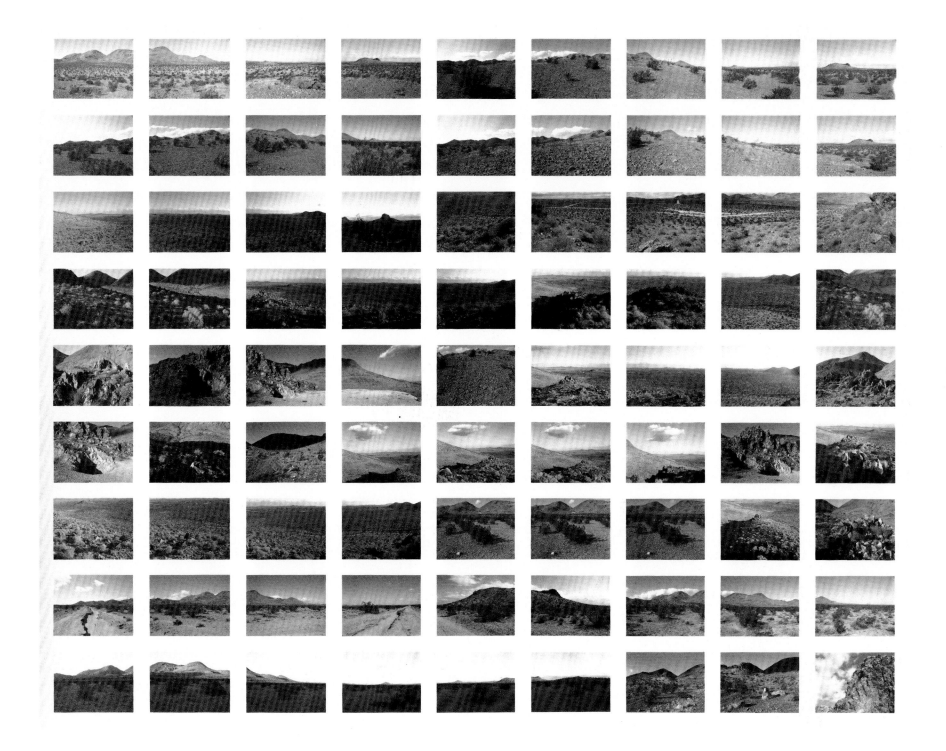

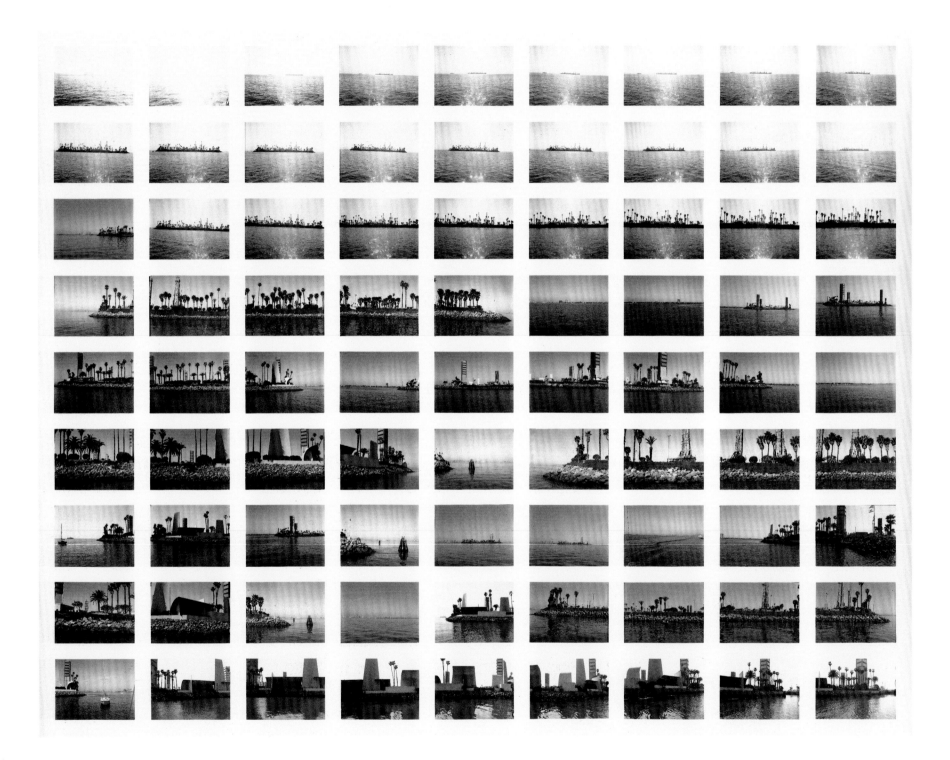

SV 51A/82

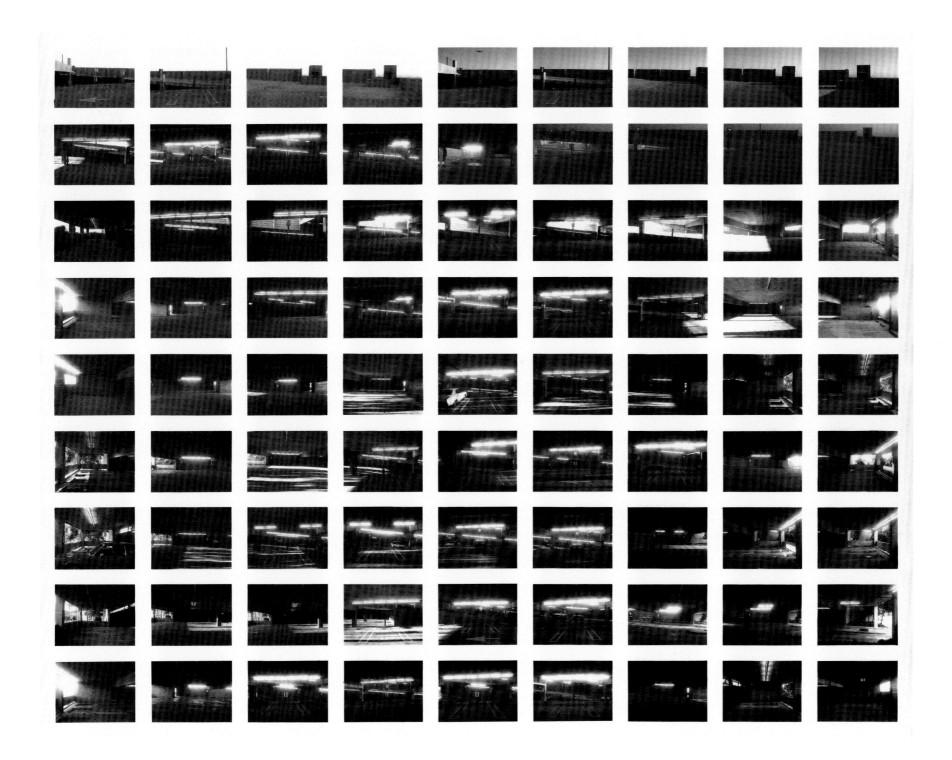

SV 47A/81 - Ocean III (dawn) 20x24"

SV 53A/82 - Surf-1 20x24"

SV 35A/81 - Near Live Oak, I Joshua Tree National Monument 20x24"

SV 56A/82 - Near Live Oak, II Joshua Tree National Monument 20x24"

SV 48A/81 - Parsons Landing, Catalina, CA 20x24"

SV 49A/81 - Bay View (Parsons Landing 2)

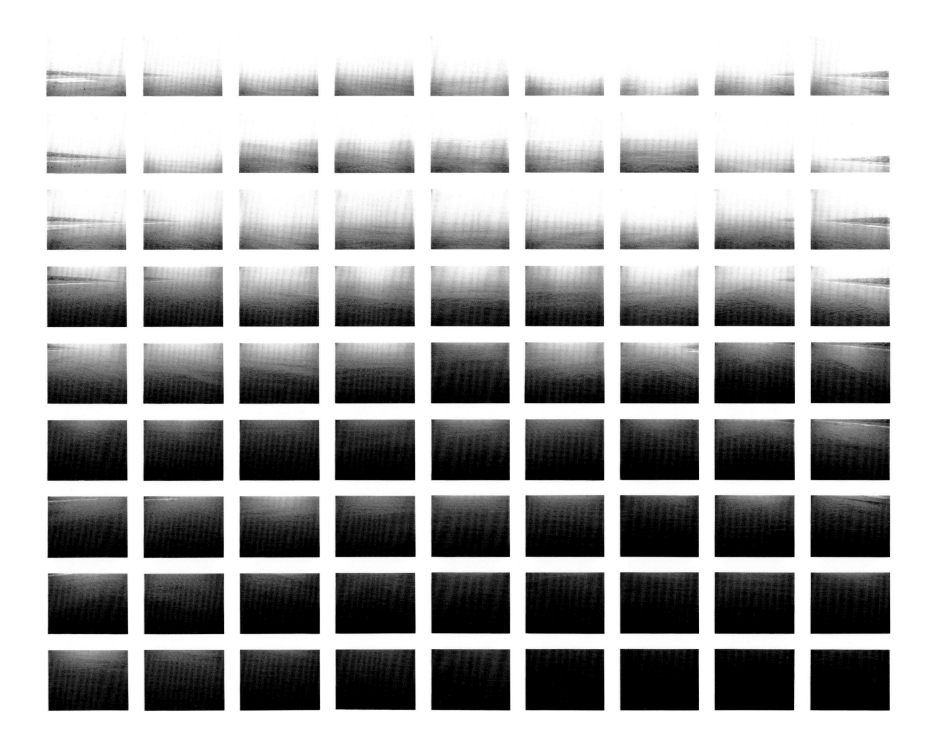

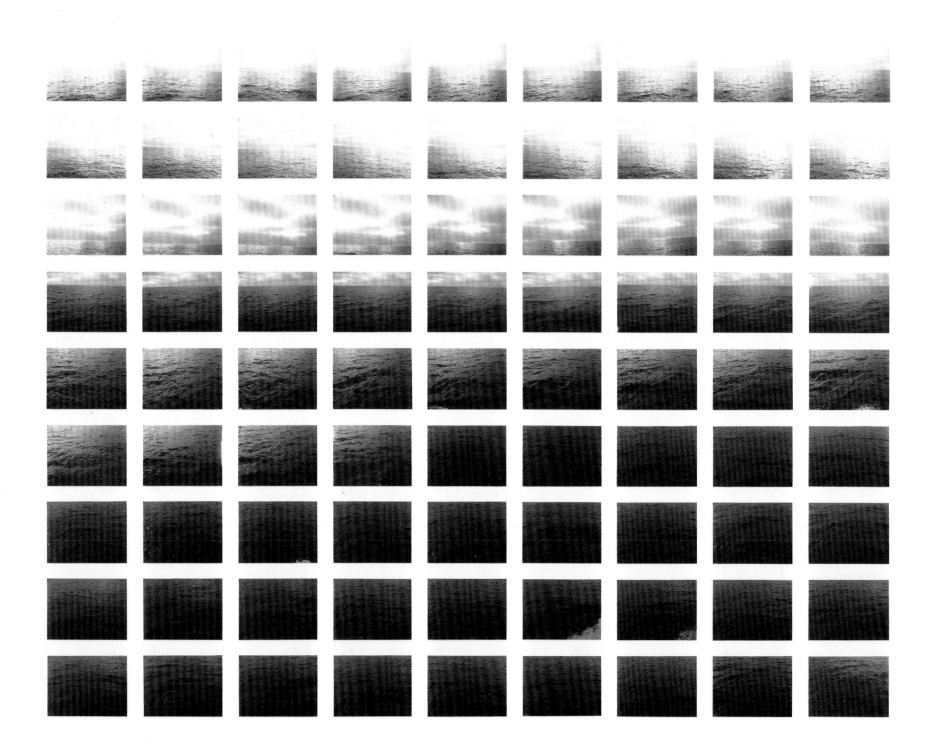

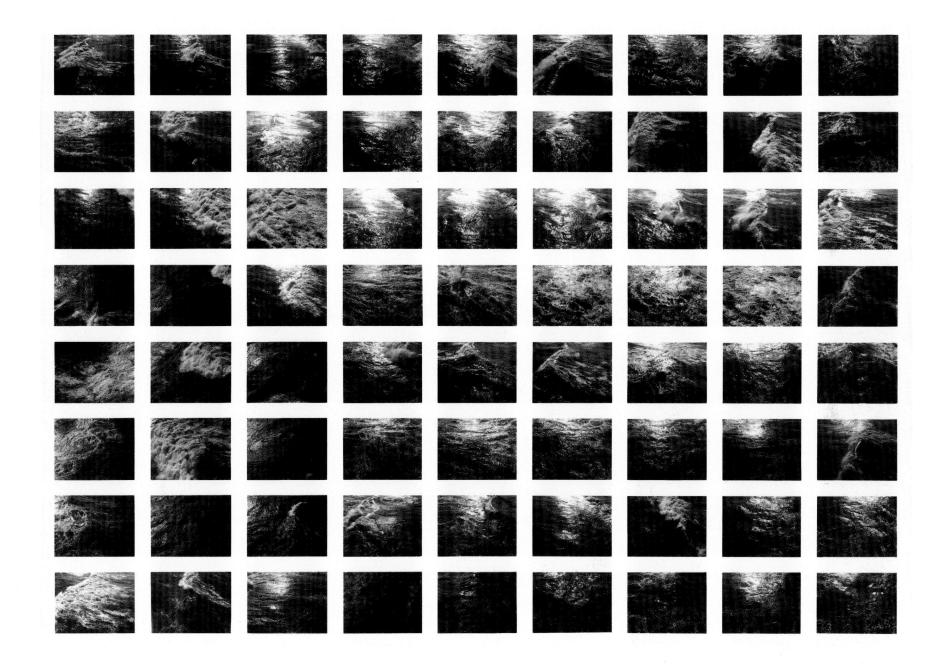

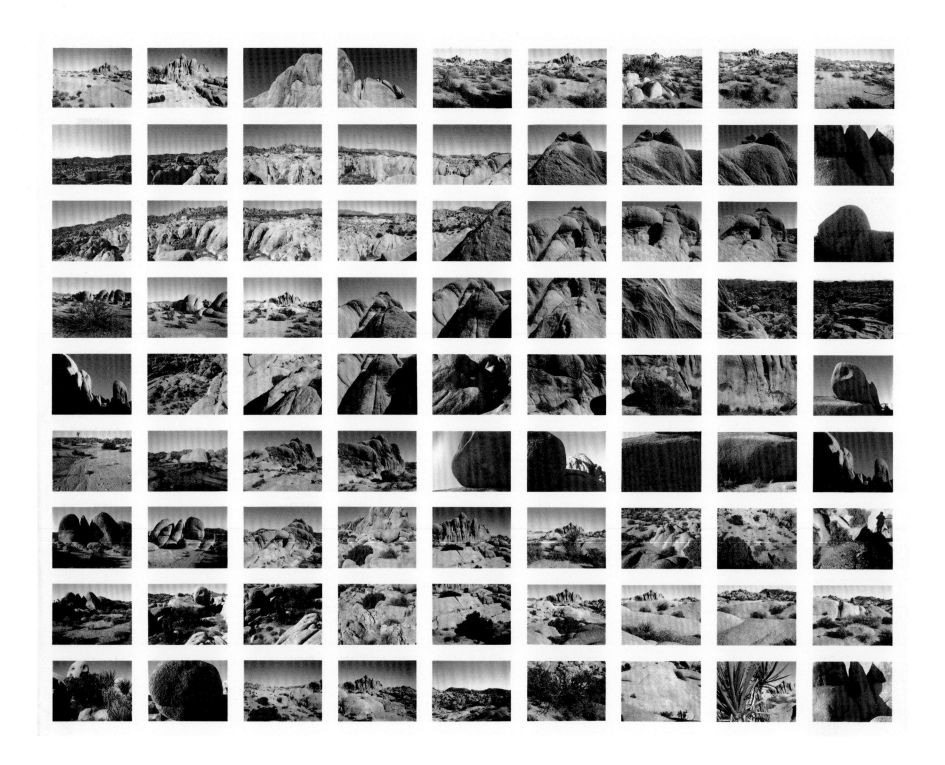

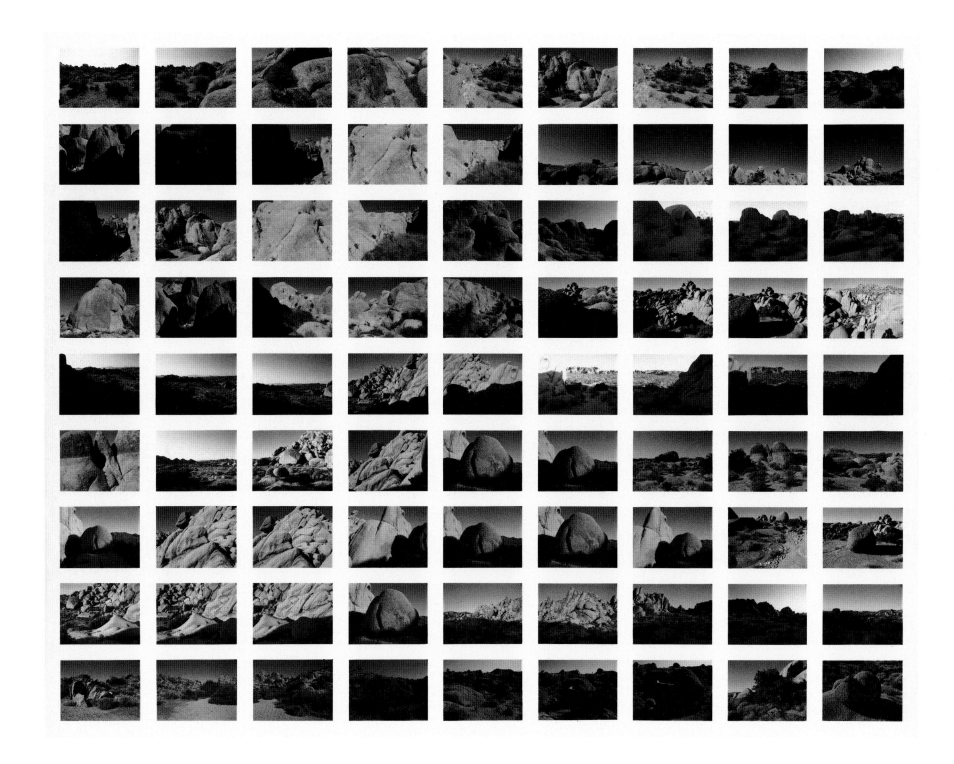

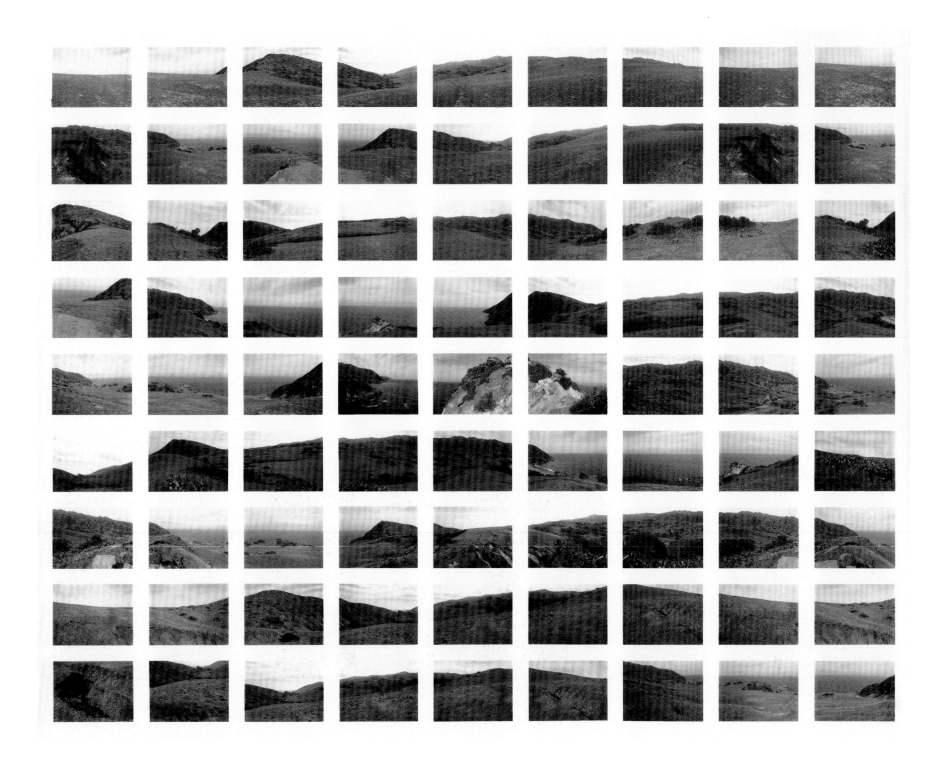

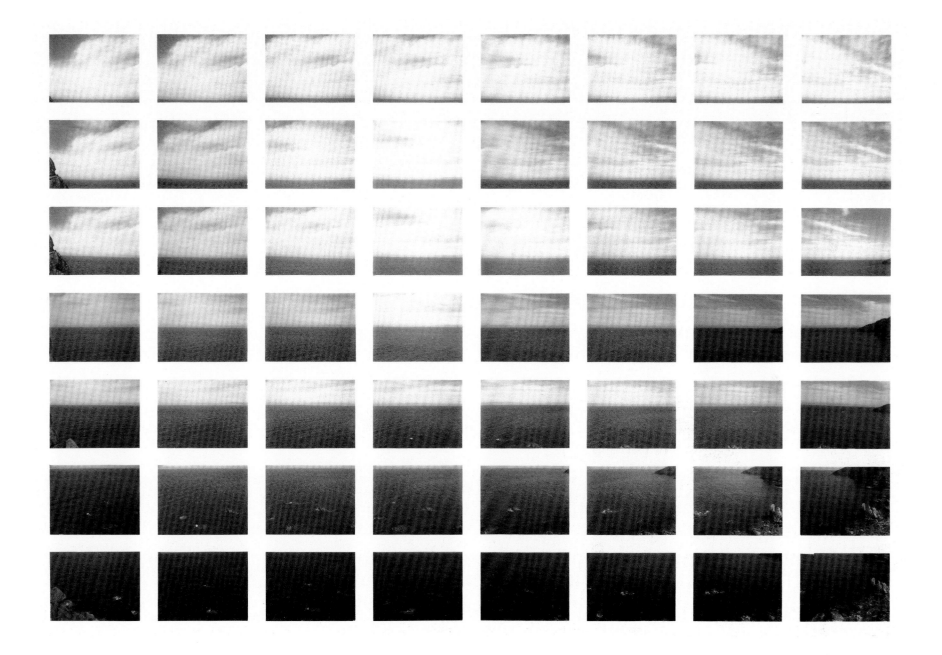

SV49A/81

AT SOLSTICE

SV 66A/82 - at SOLSTICE - Oct 22 15x20"

SV 72A/82 - at SOLSTICE - Oct 31 15x20"

SV 92A/82 - at SOLSTICE - Dec 31 15x20"

SV 110A/83 - at SOLSTICE - Mar 13 20x24"

SV 99A/83 - at SOLSTICE - Jan 23 20x24"

SV 109A/83 - at SOLSTICE - Mar 13 20x24"

SV 128A/83 - at SOLSTICE - May 15 20x24"

SV 118A/83 - at SOLSTICE - Mar 29 20x24"

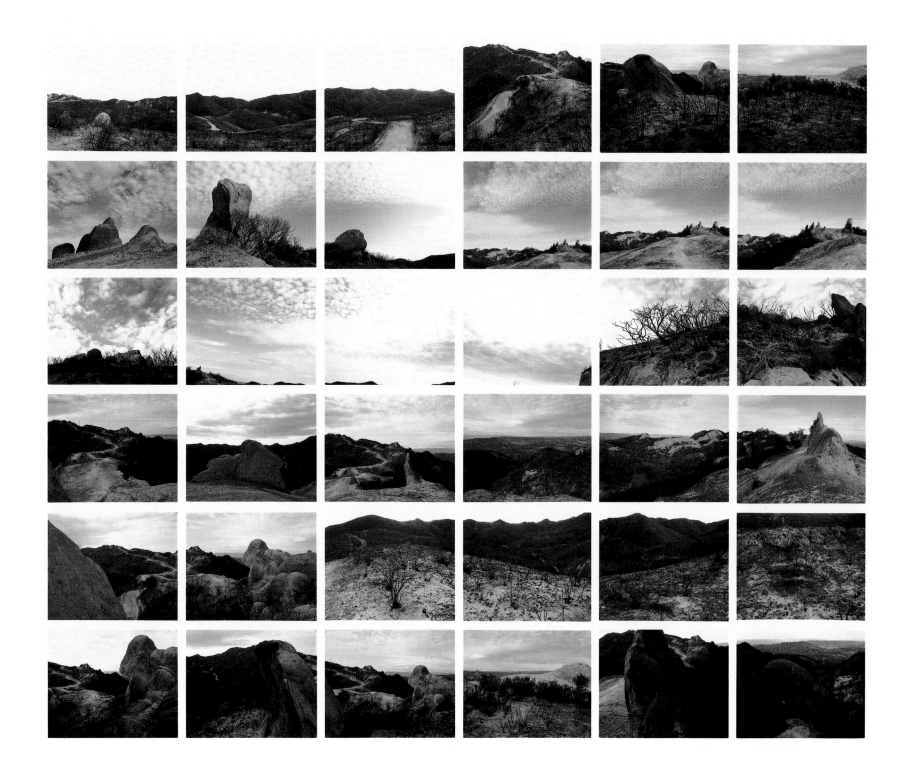

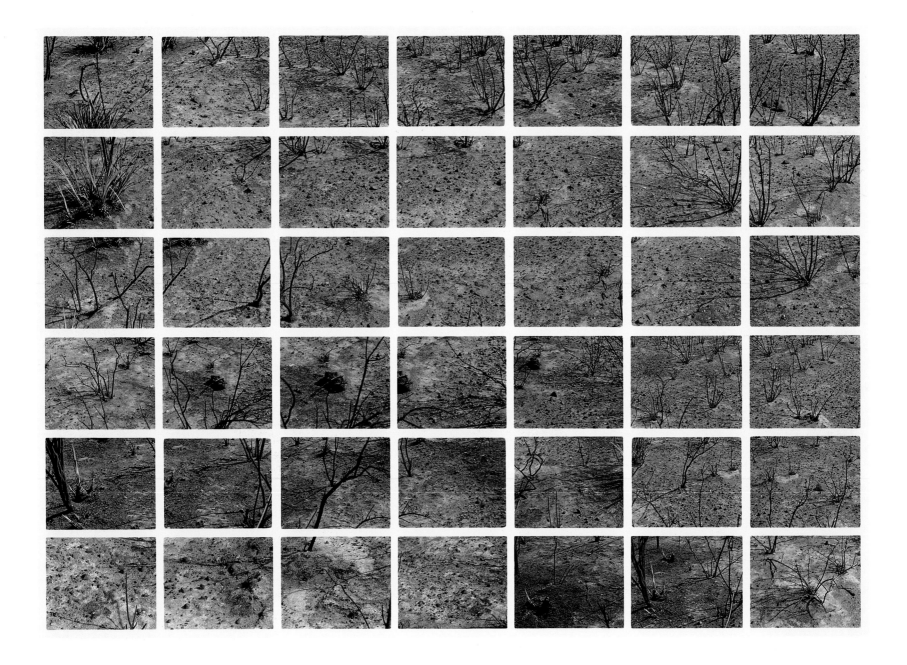

SV 72A/82

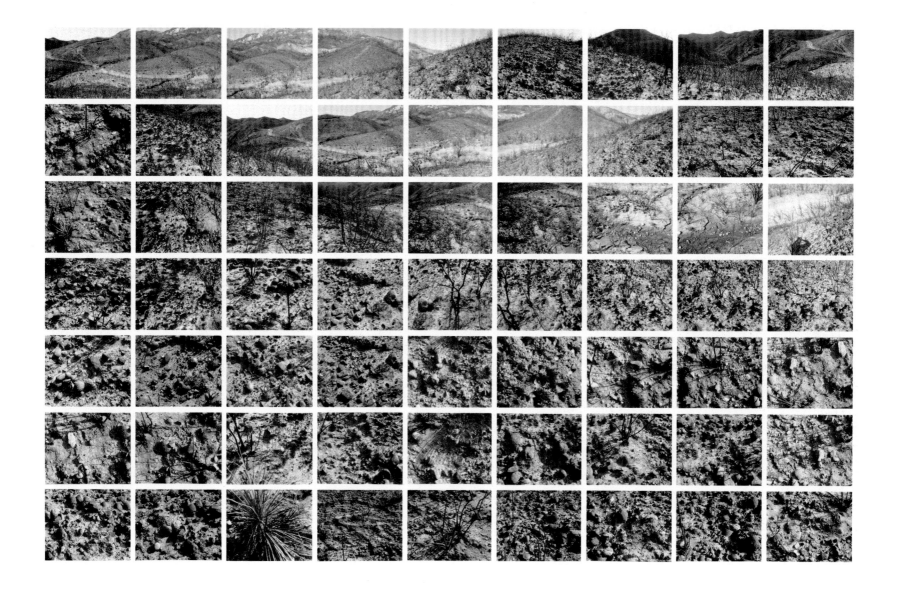

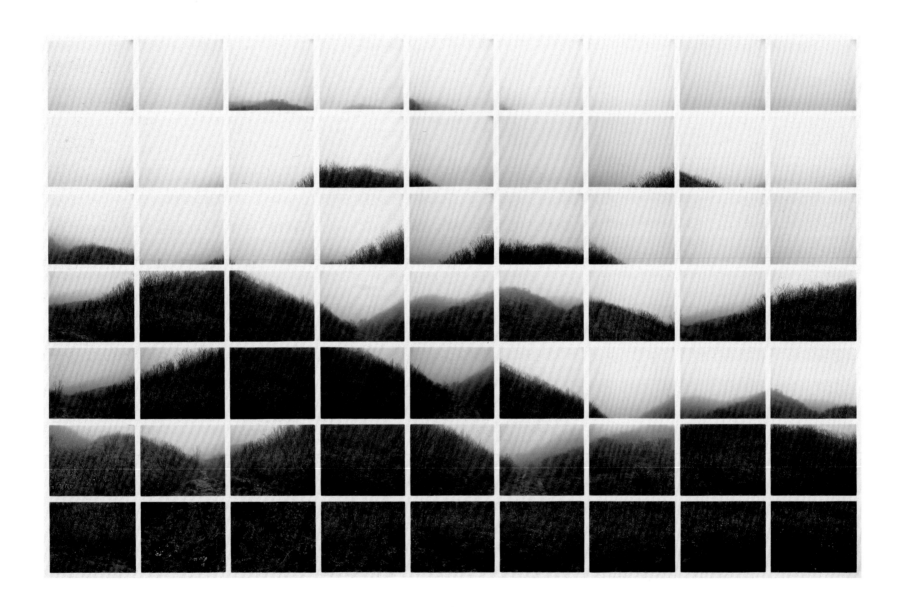

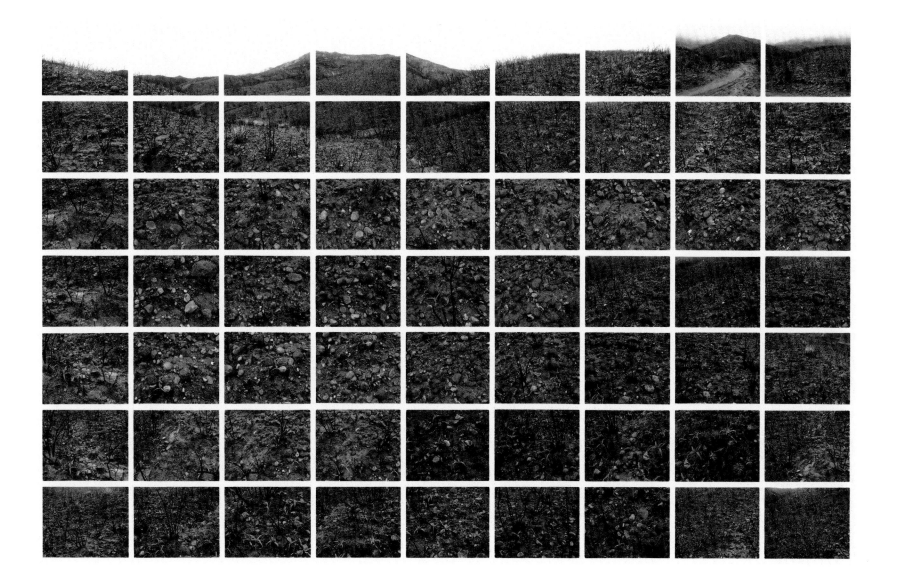

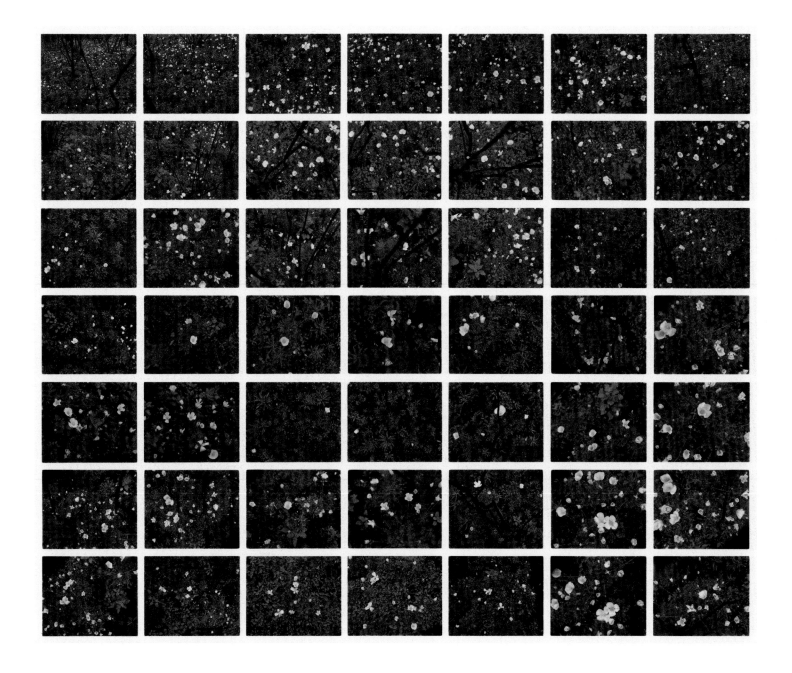

SV109A/83(Detail)

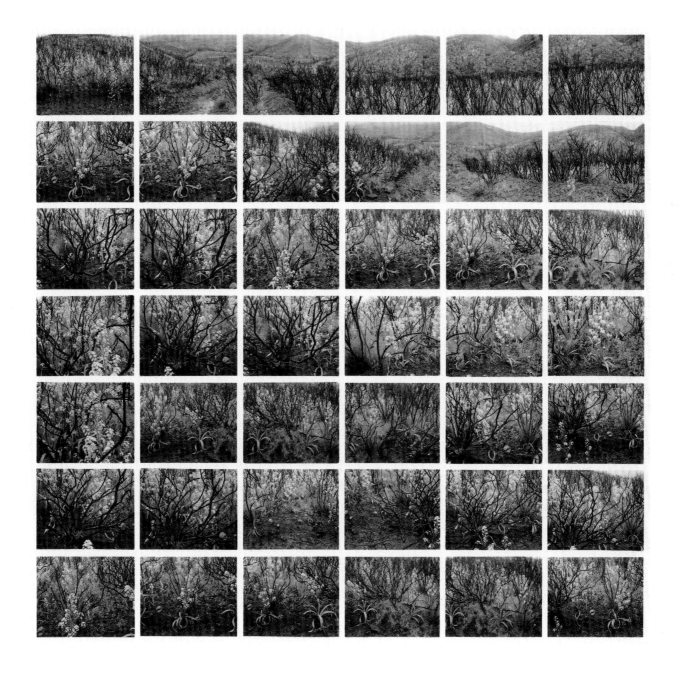

SV128A/83(Detail)

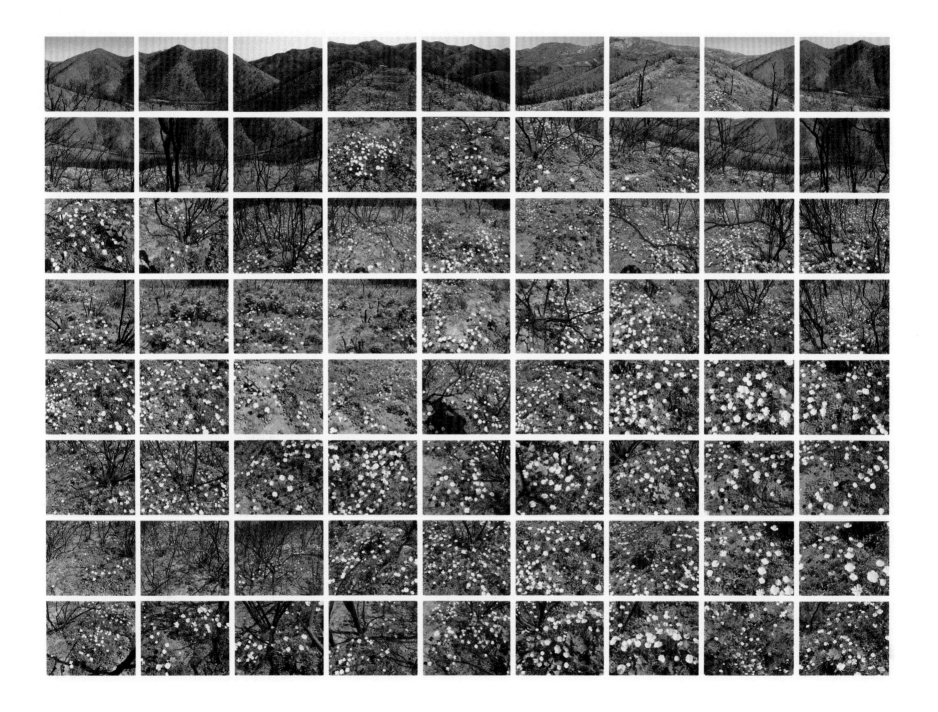

SV 150A/83 - at JOSHUA (Cholla Garden) 20x24"

SV 178A/85 - at VASQUEZ (angelflight) 15x20"

SV 265A/86 - at VASQUEZ (rockfish) 11x14"

SV 176F/84 - at RED ROCK, Haagen Canyon (looking NorthWest) 11x14"

SV 177B/85 - at RED ROCK, Haagen Canyon (shadowbird) 15x20"

SV 176B/84 - at RED ROCK, Haagen Canyon (looking East) 11x14"

SV 176H/84 -at RED ROCK, Haagen Canyon (dawn) 11x14"

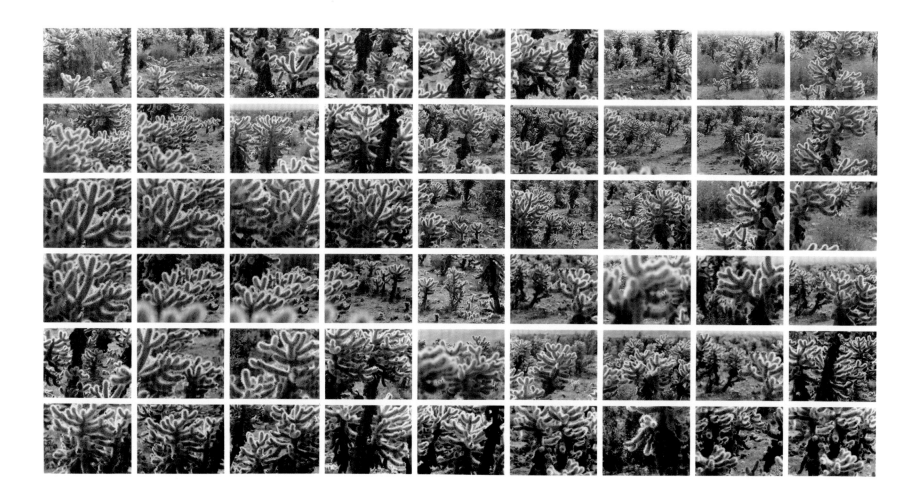

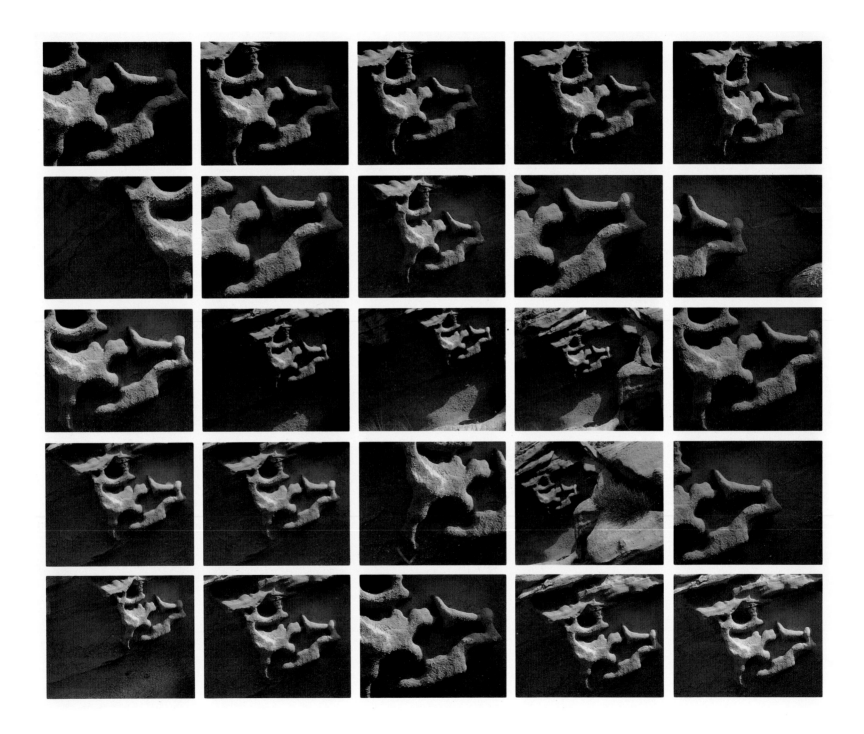

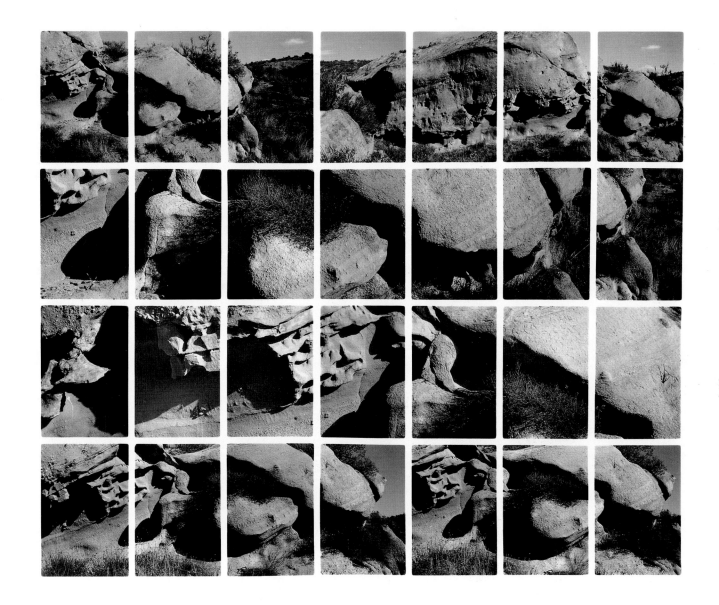

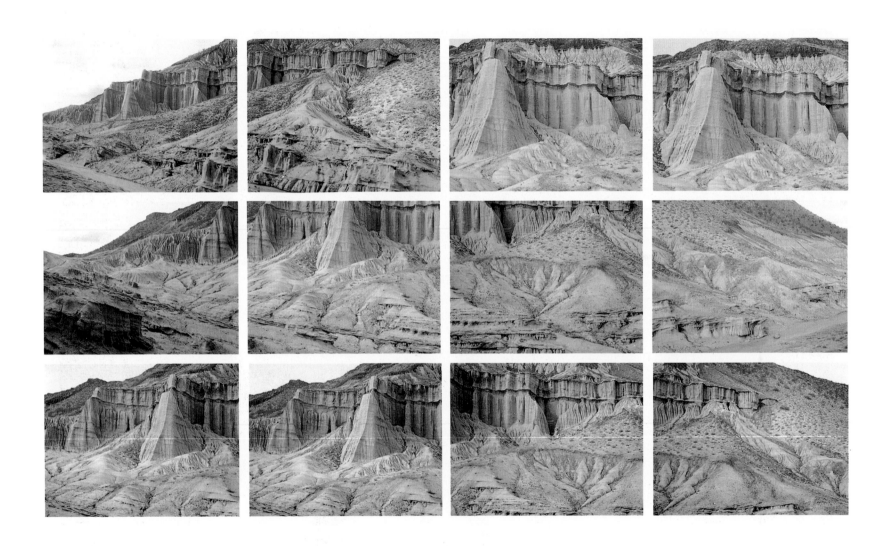

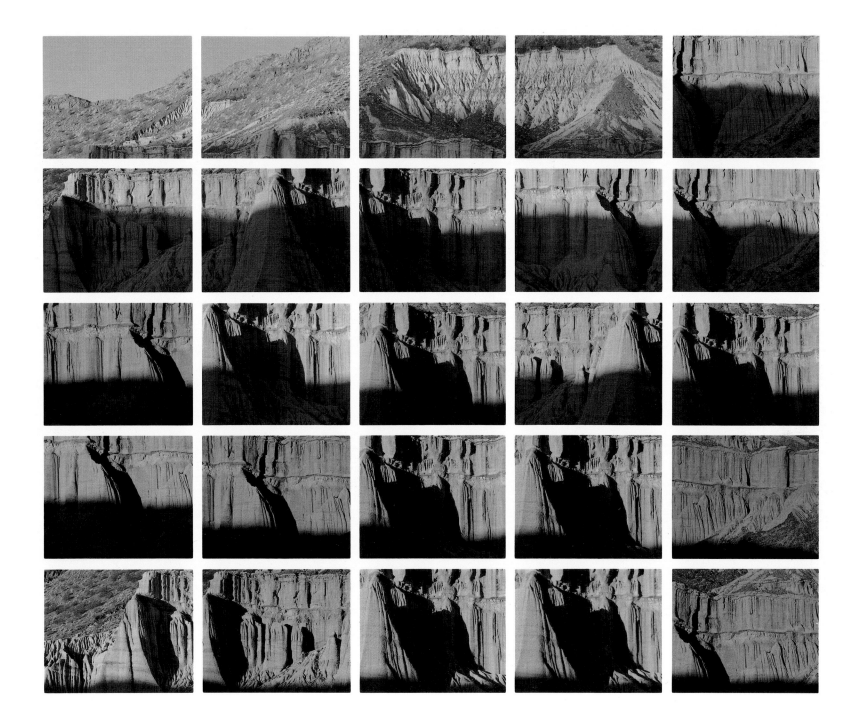

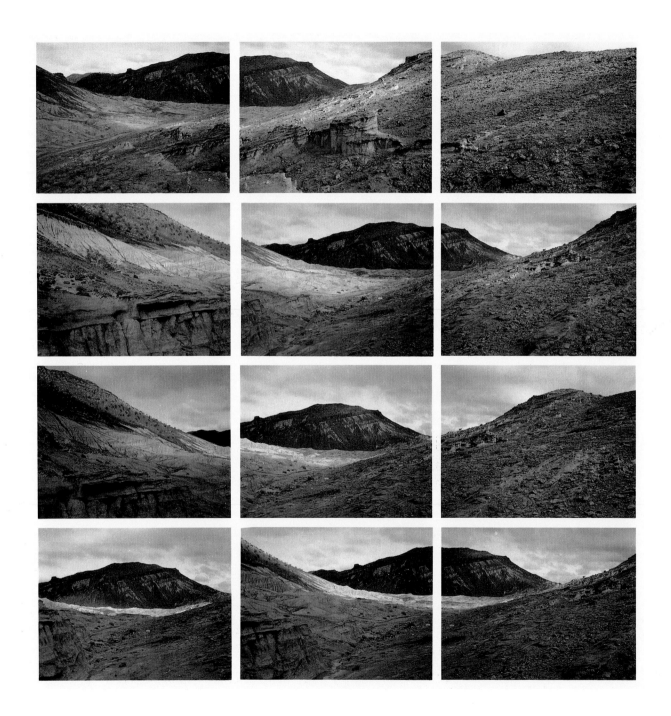

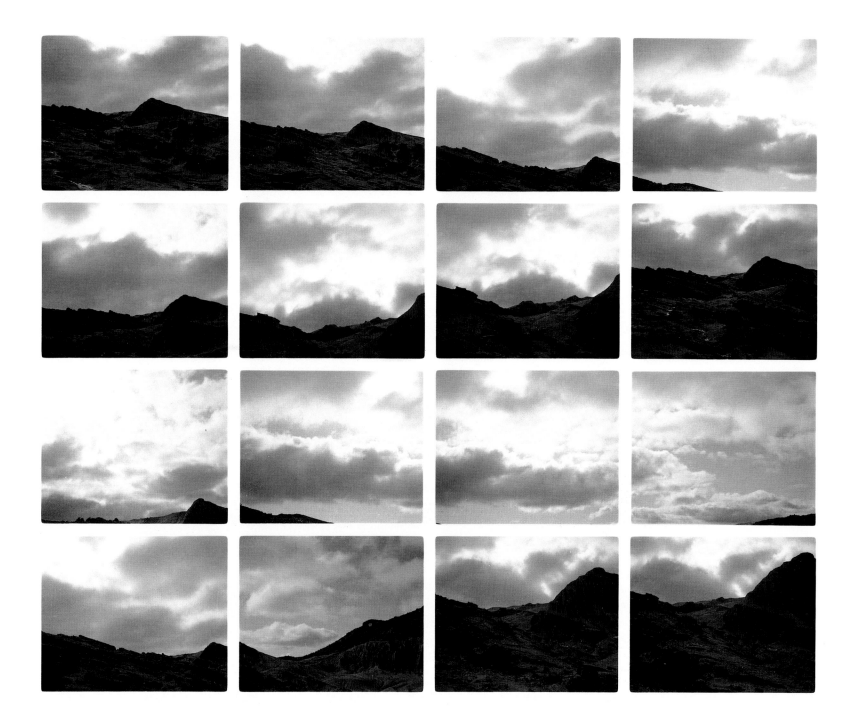

PHOTO : Susan Rankaitis

ROBBERT FLICK

ROBBERT FLICK

Personal Data :
 Born 1939 in Amersfoort, Holland
 1967 B.A. University of British Columbia, Vancouver, Canada
 1970 M.A. University of California, Los Angeles
 1971 M.F.A. University of California, Los Angeles
 Presently teaches at University of Southern California, Los Angeles

Selected Grants :
 1967 Canada Council Bursary in the Arts for Photography
 1969 Canada Council Bursary in the Arts for Photography
 1982 National Endowment for the Arts, Photographer's Fellowship
 1984 National Endowment for the Arts, Photographer's Fellowship

Selected Exhibitions :
 Over 150 since 1964, in the United States, Europe, Canada and Japan including:
 1976 Light Gallery, New York, New York (one person)
 1980 Center for Creative Photography, Tucson, Arizona (one person)
 1982 "Slices of Time : California Landscapes 1860—1880,1960—1980",
 The Oakland Museum of Art, Oakland, California
 1983 Light Gallery, New York, New York (one person)
 1984 "Photography in California : 1945—1980",
 San Francisco Museum of Modern Art (traveling internationally)
 1987 "Facets of Modernism : Photographs from the San Francisco Museum of
 Modern Art",
 San Francisco Museum of Modern Art
 1987 MIN, Tokyo, Japan

Works in Selected Collections :
 Works in over 40 museum and corporate collections in the United States,
 Canada and Europe, including :
 Center for Creative Photography, Tucson, Arizona
 International Museum of Photography at George Eastman House,
 Rochester, New York
 National Gallery of Canada, Ottawa, Ontario

Selected Publications :
 Wise, Kelly, ed., The Photographers' Choice (Addison House, Danbury,
 New Hampshire, 1975)
 Porter, Allan, ed., "Los Angeles Documentary Project 1981" Camera (Lucerne,
 Switzerland), Feburary 1981
 McKinney and Ranney, An Open Land : Photographs of the Midwest 1852—1982
 (Art Institute of Chicago, Chicago Illinois 1983)

ロバート・フリック

出生地　　１９３９年　　オランダ、アマースフールト
　　　　　　１９６７年　　カナダ　バンクーバー市、ブリティッシュコロンビア大学より
　　　　　　　　　　　　　学士号取得
　　　　　　１９７０年　　UCLA（カリフォルニア大学ロサンゼルス校）より修士号取得
　　　　　　１９７１年　　UCLAより芸術修士号取得
　　　　　　現　　　在　　ロサンゼルス、南カリフォルニア大学にて教えている

受賞歴　　１９６７年　　カナダ、バーサリー・カウンシル写真芸術部門
　　　　　　１９６９年　　カナダ、バーサリー・カウンシル写真芸術部門
　　　　　　１９８２年　　国立芸術基金、写真家部門
　　　　　　１９８４年　　国立芸術基金、写真家部門

展覧会　　１９６４年以来、米国、カナダ、ヨーロッパ等で１５０以上に渡る展覧会
　　　　　　に出品。主要なものは以下の通り。
　　　　　　１９７６年　　ニューヨーク、ライトギャラリー（個展）
　　　　　　１９８０年　　アリゾナ州ツーソン、センター・フォー・クリエーティブフォト
　　　　　　　　　　　　　グラフィー（個展）
　　　　　　１９８２年　　「カリフォルニアの風景：1860-1880、1960-1980」
　　　　　　　　　　　　　オークランド美術館
　　　　　　１９８３年　　ニューヨーク、ライトギャラリー（個展）
　　　　　　１９８４年　　「カリフォルニアの写真：1945-1980」
　　　　　　　　　　　　　サンフランシスコ近代美術館（国際巡回展）
　　　　　　１９８７年　　「モダニズムの形態：サンフランシスコ近代美術館収蔵の
　　　　　　　　　　　　　写真作品より」サンフランシスコ近代美術館
　　　　　　１９８７年　　東京、ギャラリーMIN

コレクション　40を越える美術館や企業コレクションに作品は収蔵されている。
　　　　　　主な収集先：センター・フォー・クリエーティブフォトグラフィー（アリゾナ州ツーソン）
　　　　　　　　　　　　　ジョージ・イーストマンハウス国際写真美術館（ニューヨーク州）
　　　　　　　　　　　　　オタワ市、カナダ国立ギャラリー

主な出版物　１９７５年　　「写真家の選択」
　　　　　　　　　　　　　アディソンハウス刊　ケリー・ワイズ編
　　　　　　　　１９８１年　　「ロサンゼルス・ドキュメンタリー・プロジェクト1981」
　　　　　　　　　　　　　「カメラ」誌1981年 2月号　アラン・ポーター編
　　　　　　　　１９８３年　　「開かれた土地：アメリカ中西部の写真1852-1982」
　　　　　　　　　　　　　シカゴ・アート・インスティチュート　マッキニー＆ラニー著

ROBBERT FLICK

Sequential Views 1980 - 1986

September 12 ~ October 6, 1987

Publisher : GALLERY MIN
Editorial Planner : MIN J. SHIROTA
Editorial Assistant : KAORI HASHIMOTO
U.S.A. Coordinator : THERESA LUISOTTI, MARK GREENBERG
Essay : MARK JOHNSTONE
Cooperators : NORIYOSHI SUZUKI, KIYOTAKA TANINO, YASUSHI KUMON
Printer : MITSUMURA PRINTING Co., Ltd.

発行： GALLERY MIN
企画：城田 稔
編集アシスタント：橋本かおり
U.S.A. コーディネーター： THERESA LUISOTTI, MARK GREENBERG
エッセイ： MARK JOHNSTONE
協力：すずきのりよし，谷野精隆，久門　易
印刷：株式会社光村原色版印刷所